UNMADE BEDS

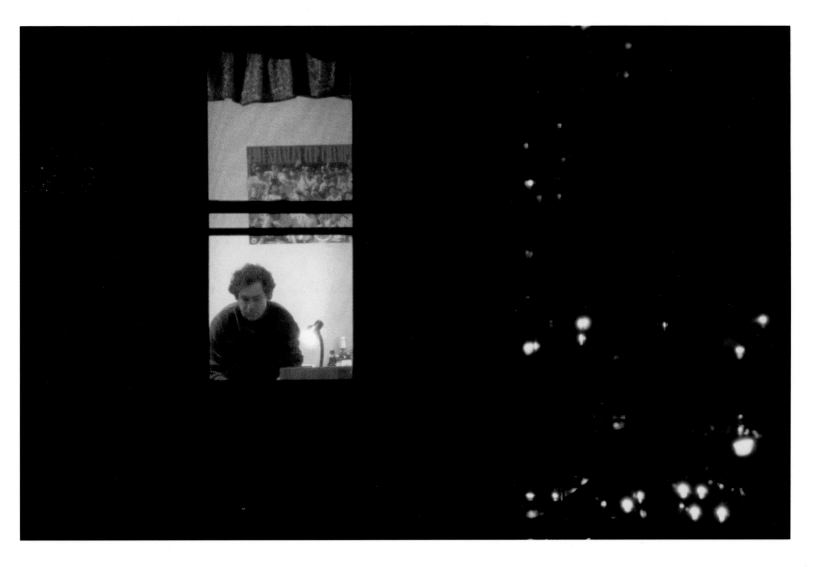

# Unmade BEDS

NICHOLAS BARKER

DEWI LEWIS PUBLISHING

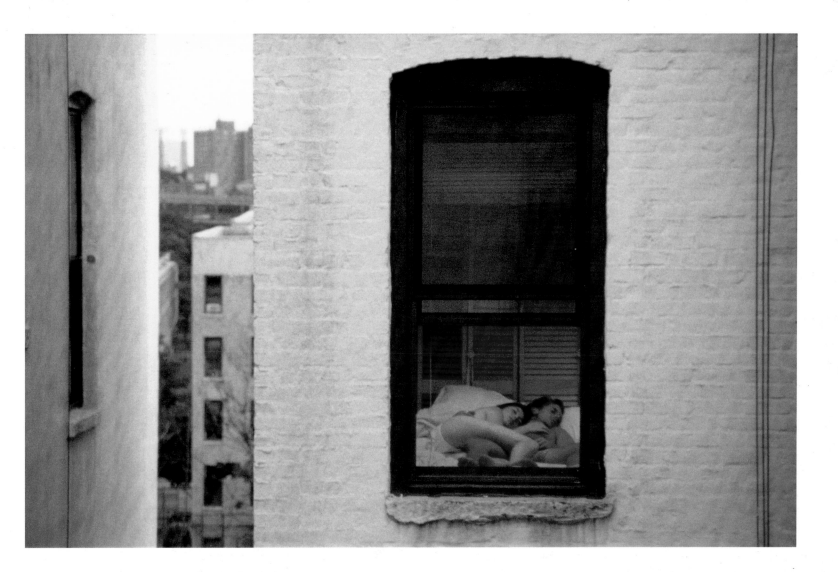

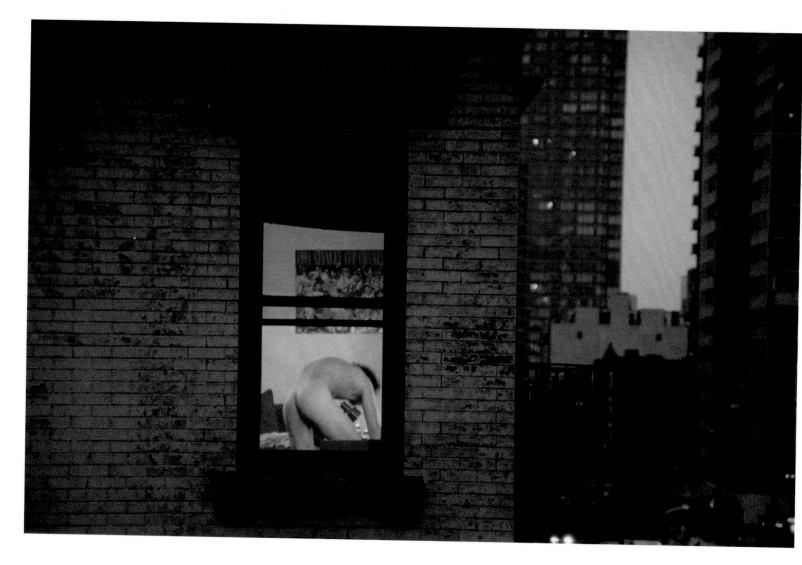

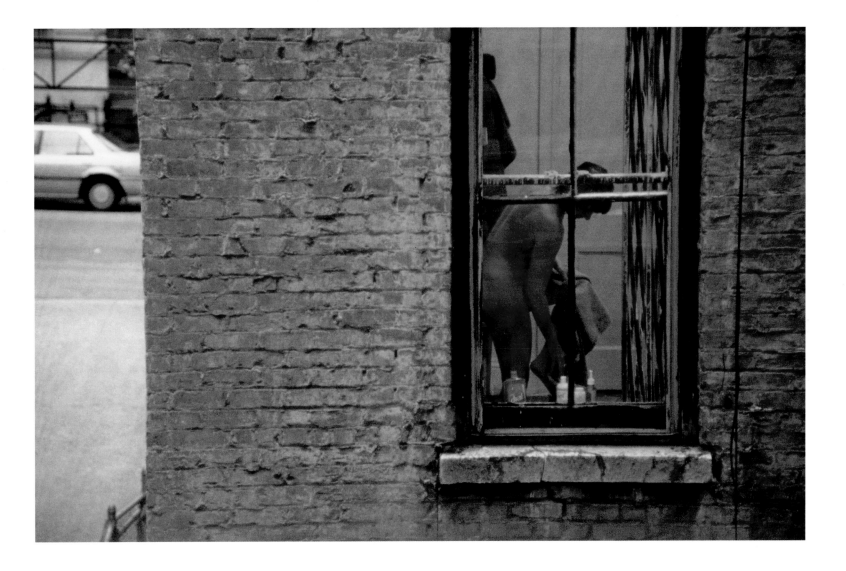

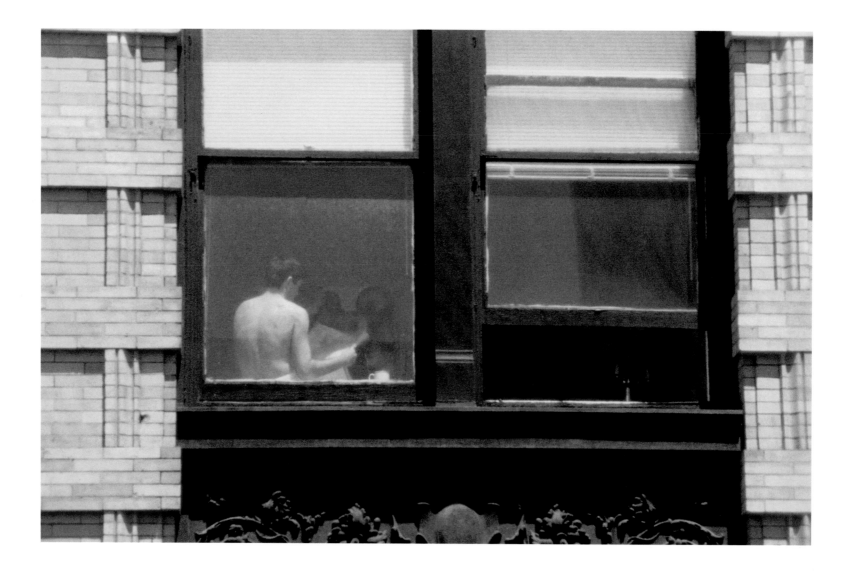

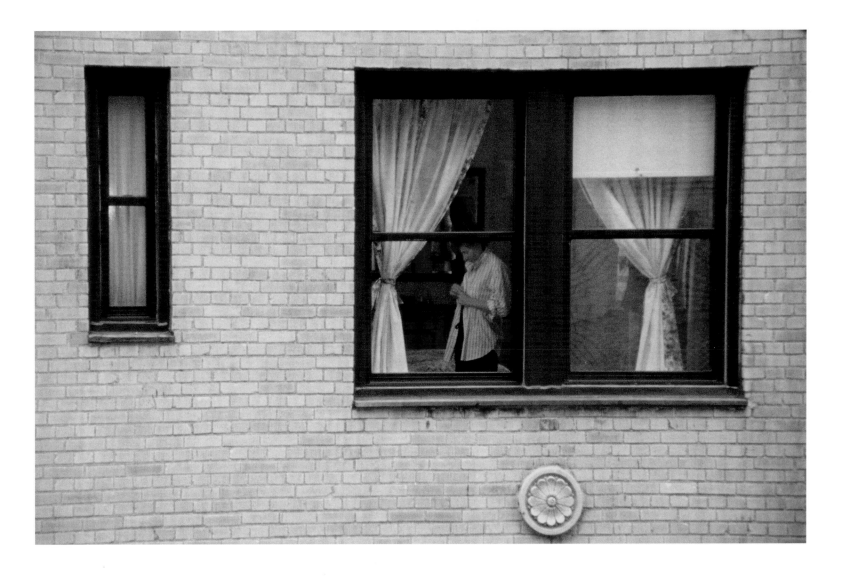

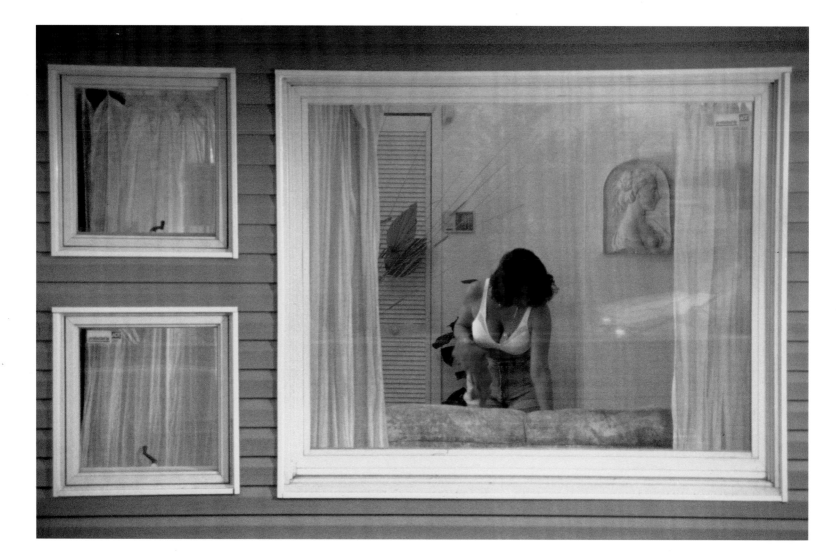

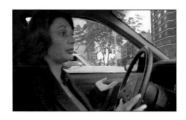 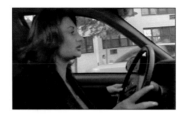 

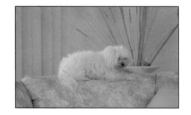  

■□□
□□□
□□

The problem is, I'm seriously fucked up about money right now. Money has always been my problem. I have no other problems. My income is 2000 dollars. I have 3000 dollars of expenses every month. There's no way you can make that work.

□■□
□□□
□□□

The most likely solution to this financial problem is a man. Because men have been propositioning me all my life, for all kinds of things, for money. I mean, they have given me money to do everything from hang out with them, get high with them and God knows what else. So now I decided that the personal ads are a way for me to proposition a man. Really all it is: I want a man to give me money, help me with the things I need, and go away. And in return we'll have sex a couple of times a month – maybe four. We'll work out some kind of arrangement depending on what the man looks like.

□□■
□□□
□□□

I mean dick is easy to get. I don't need dick. Dick is all around. You just reach out any time you want and you'll be able to grab a dick. That's not what I need. I need cash. That's what I want from a man.

□□□
□□□
□■□

I always knew Italian men cheated and ethnic men cheated. Because most of the time they have a big dick and they want to show it to the whole female population. Italians would cheat on anybody. They'd cheat on Raquel Welch. I have accepted that, unfortunately. But my girlfriends used to say to me "It's the type of guy you go out with. You should try Jewish men." Which I thought meant that Jewish men didn't cheat. But I was so wrong.

□□□
□□□
□□■

They'd call up. And as soon as I heard that nasal thing that turns me off I'd say "Are you Jewish?" And they'd say "Yeah". And I'd say "I'm sorry, I think Jewish men have no sex appeal. I'm not attracted to Jewish men." Because it's an ad. You don't have to be nice. And they'd say "How could you say that! I think I have a lot of sex appeal!" And I'd say "I doubt it. I've never met a Jewish guy that had any sex appeal." And they'd say "What about Burt Lancaster? What about Kirk Douglas?" And I'd say, "Well, Burt Lancaster and Kirk Douglas are great actors but I don't think either one of them has any sex appeal. I wouldn't sleep with either one of them." But then, the one Jewish guy that I thought was really sexy is Tony Curtis. Tony Curtis was hot. I would sleep with him now just for how sexy he used to be.

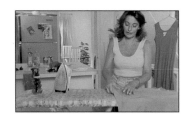 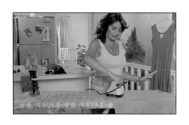 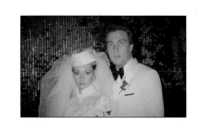

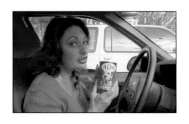 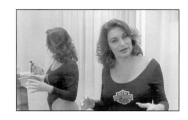 

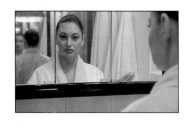 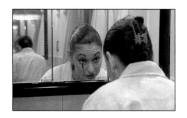 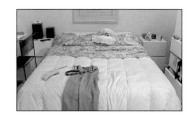

There was this guy who called me up and said "I'll give you 500 a month plus pay all your bills if you put me into service with you" which he explained meant that I had to beat him up for money. So I was like – every time I can have money from men without sex – that interests me. Now you are talking my language. What is it exactly that I have to do? And he said I had to beat him up. And if I knocked him out, I got extra.

So I said, "Well the only way I could build up the animosity to be able to beat you up is if I imagined that you were my ex-husband. Then I could probably find a reason to hurt you."

Because I spend so much money that I don't have on items that I have to buy, I shoplift a few things – the items that are small but pricey, like shampoos and aspirin. And things like dog food. I always steal dog food. They're God's creatures and I should not have to pay for it. It should be given to me.

The thing that bothers me is everybody used to say "you have a nice body, you have a nice body" all the time. Now they say "You have a nice body". And they add on this little phrase: "for your age". Like, when did that happen? When did that become part of the sentence?

When men look at me, I look like sex. They think of sex. They want to fuck me in an alley. They want to take me to a bizarre, odd place like an elevator shaft to do some kinky thing. And they think that's what I'm into. But I'm not. I'm not kinky at all. I used to think that I had to learn to be kinky to live up to their expectations.

I realise that by exaggerating this slutty look I attract men that way even more. But it doesn't matter. It's what I look like. It's what I'm comfortable with. It's what works for me. And that's it.

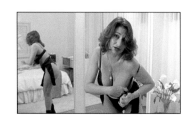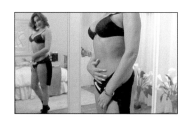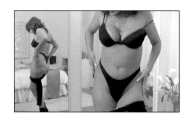
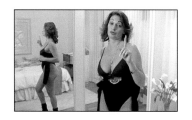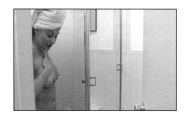

I've been lucky with my chest. My chest is good, I'm not drooping or anything. And, by the way, this is where I stash my drugs. There is this little spot and you stick it in there. That's my favourite spot.

Now, my stomach used to be really, really flat. But now I have to work out and I hate that. Because I never used to have to. It's not that bad yet. I can still wear my slutty clothes but I have to tone my act down a little bit. I can't have as much revealed as I used to.

The other thing that blows my mind is: as I get older this new thing happened. It used to be that if I wore the real tight, clinging, slutty dresses, I didn't have to worry about the thigh thing. But now I've got this new indentation. It goes in and out – right there! When did that happen? I don't remember it happening. I must have woken up one day and it was there. And I never saw it before. It blows my mind and it really aggravates me.

The other thing which I think is real important is that you keep a tan all year. Because no matter how little you sleep, how much drugs you do, if you have a tan, you look healthy. Which to me is all that matters.

Now the real beauty secret that I think I have is: for years, since I was thirteen or fourteen, I have been putting baby oil on while I'm still wet. I find that it makes me have really nice soft skin. I've always done it. I never take a shower without it. And the thing that amazes me is that men who normally don't even notice if you have two eyes, two legs and two arms, always notice that I have very soft skin and they always say "Wow, how come your skin is so soft." Like it's a really big thing. And I say, "That's because I've been putting baby oil on my skin when I take a shower since I was 15."

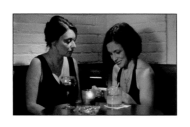
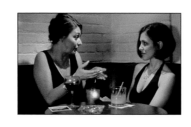

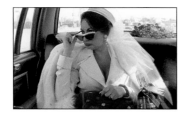
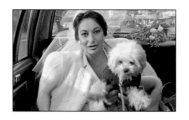
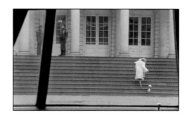

**BRENDA:** I'm really thinking of going ahead and marrying that guy for the money.
**GINA:** What do you have to do for the money? Do you have to, like, live with him?
**BRENDA:** What I plan to do is take the money, go to City Hall, get married and say "See ya".

**GINA:** Is he cute?
**BRENDA:** Oh, he is so handsome! Do you wanna see a picture? He looks just like Eric Estrada. You're going to be jealous! Imagine introducing him to somebody as my husband. But I mean, I don't have to look at him.
**GINA:** You don't think you're ever going to get married for love?
**BRENDA:** I certainly hope not.
**GINA:** Maybe I need to get a little bit more jaded.
**BRENDA:** Look, get married. When you get divorced – which you will – then you see how you feel about it. Like I think of it this way now. If you get married when you're fifty you're gonna live another 20 or 30 years most likely. So if you live to be like 70 or 80, that's 20 or 30 years with one person. Isn't that enough of your life to be living with one person? Like why do you have to live your whole life with one person?

I decided that if I was gonna do this wedding thing, I was gonna do it in style – like I almost meant it. So I'd had to do the "old, new, borrowed, blue thing". Because it's bad luck if you don't. So my shoes are old. Because I bought them at the Jersey Shore a couple of weeks ago. That makes them old. My suit is new, which is a 400 dollar Dimitri suit. And I paid 129 dollars which I thought was a great deal. 'Blue' is my garter belt which the fucking immigrant Angel Lopez – my future husband – will never see. And the 'borrowed' is my friend Rosemary's coat and if anything happens to it I will just die.

Toto is the only male that I really, really care about in this world. He's my favourite, favourite male. Look how excited he is. He is so happy. We're going to party later, me and Toto. His tongue hangs out because he has no teeth – poor thing. But he doesn't have to chew champagne. He can drink champagne. And we'll have a big party. Me and Toto, and 10,000 dollars!

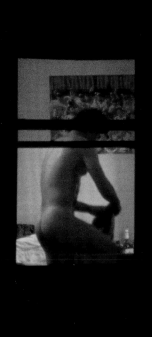

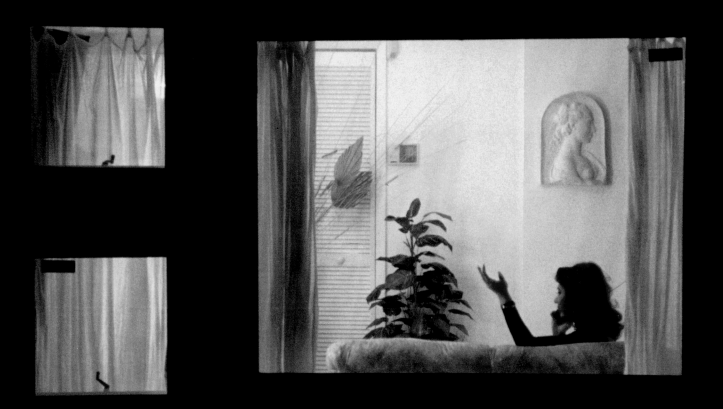

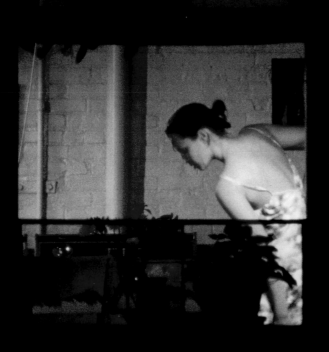

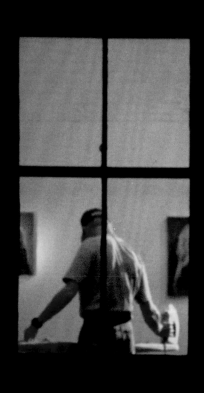

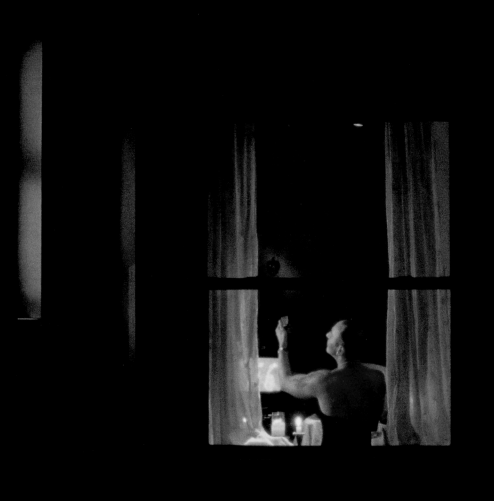

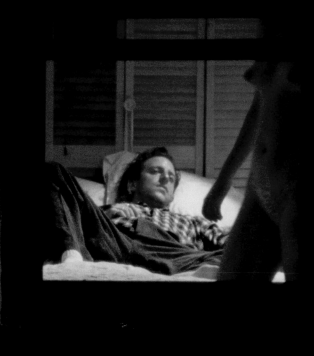

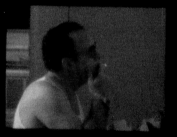

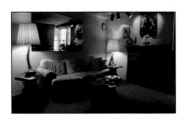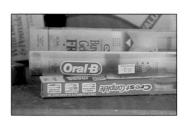
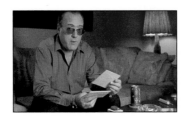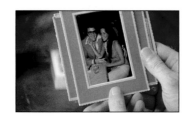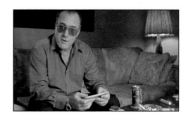

▢■▢
▢▢▢
▢▢▢

This is my cave. This apartment says to every woman that comes here "You are here to fuck. If you are not here to fuck, leave. End of story." There are nudes on the wall. A very dimly lit apartment. In the bedroom there are mirrors on the wall.

▢▢■
▢▢▢
▢▢▢

The women that come here to fuck will find that there are things in the cupboard just for them. There is Playtex, Wet Naps, Stayfree Maxi Pads, in case they have that thing going on. And brand new toothbrushes. And I'm not cheap. They get new Oral B's.

▢▢▢
■▢▢
▢▢▢

Here's Betty – a waitress. But she didn't work for me. I never went out with a waitress who worked for me. Because my mother has a saying "You don't shit where you eat." I don't go out with mutts. I only go out with beautiful women. The way I see it is that they're the beauties and I'm the beast."

▢▢▢
▢▢■
▢▢▢

So, have I bullshitted you about the women in my life? And that's what annoys me about the personals. They say they are all beautiful women, and when they show up, they're mutts. I've never gone out with a mutt and I'm not gonna now.

▢▢▢
▢▢▢
■▢▢

WOMAN: What do you do?
MIKEY: I write screenplays – mainly dramas – for major production companies like Miramax and Sony Pictures. Companies like that. I make up stories about beautiful women and how this main character who is always called Michael ...
WOMAN: You are always writing stories about yourself.
MIKEY: ...about myself and my fantasies.

▢▢▢
▢▢▢
▢■▢

WOMAN: Do you write any funny stories?
MIKEY: No, I don't write comedies. I write stories about women abandoning and dumping men. Which is what women do all the time. They break men's hearts.

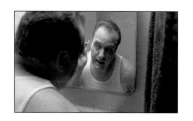 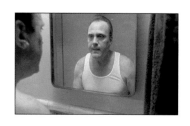 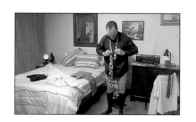

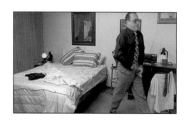  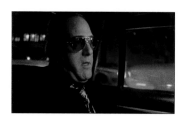

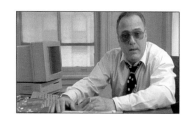 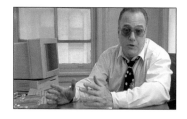 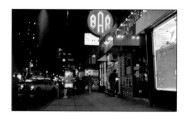

■□□
□□□    You see the shit I gotta go through to impress these women. I get the hair coloured. Shave. Now I gotta clip the ear hair, so they
□□□    don't think I'm an old fuck. Because only an old chicken has hair coming out of their ears. And women know that shit. Now I gotta
         clip the nose hair.

□■□
□□□    Well, this is it lady, what you see is what you get.
□□□

□□■
□□□    I have high standards for women but I never thought of myself as a pretty boy. It doesn't bother me that I've got a bit of a gut. And
□□□    I'm starting to get a receding hairline. Because Michael is still Michael.

□□□
■□□    I was never the Robert Redford or Paul Newman type. I was always more the Jack Nicholson or Harvey Keitel kind of guy.
□□□

□□□
■□□    When I go on a blind date with one of these women, and the first question they ask me is, "What do you do?" I lie. I tell them I'm
□□□    a first-run screenwriter. Now, I do write screenplays. But I've never sold one. But I tell that lie because I know I'm never gonna see
         them ever again. And I don't care because the only thing they're interested in is my social status and how much money I have.

□□□
□□□    People on the Internet dating services are living in a fantasy world. And to me that's very sad. When this woman who lives in
■□□    Telluride, Colorado contacted me on the Internet, and told me that she looked like Linda Evans, I said, "Ok, if you look like Linda
         Evans, prove it to me, send me a picture."

□□□
□□□    Now, my profile on the Internet clearly stated that I was looking for a woman between the ages of 25 and 45. When I got her
□■□    picture, she looked like she was somewhere in her 60s. And she was extremely fat. She looked nothing like our Dynasty star Linda
         Evans. So I wrote her back, through the Email: "Telluride....we have a problem."

□□□
□□□    So I guess what I gotta do to find that special woman, is get back into the New York bar scene. And one of the things that I will
□□■    do, is get the bartender on the side, introduce myself, and give him a ten dollar bill for the cup. And tell him, "When you're going
         to serve a drink for these single young ladies, charge it to me." And that way, I get to see which way things are going to flow. And
         I will go in that direction.

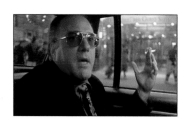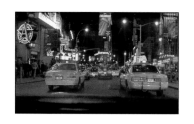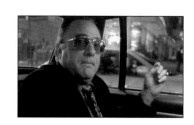

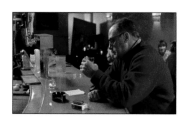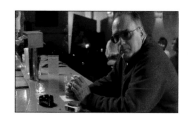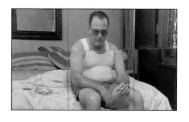

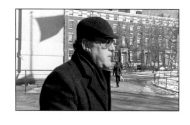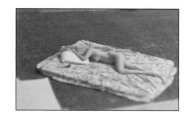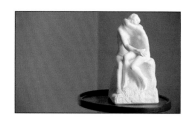

It's almost Thanksgiving. And this is a really tough time of year to meet women because nobody wants to be alone for the holidays. And anybody that's in a relationship, isn't going to break up. And I had a really shit date last week. As soon as she walked through the door, I knew I was in trouble. Because she was a real mutt. The only thing that saved me, was when I go on these blind dates, I carry my beeper. So, after ordering her a drink, I excused myself. Went away for a few minutes. And when I came back, my beeper goes off. And I tell her, I have to leave. If it wasn't for the beeper I'd be in real trouble.

Getting older is really shitty. Yesterday I went to the Angelika Theatre. I gave the girl at the window a twenty dollar bill. I walked inside to buy a bottle of water expecting to see twelve dollars in my hand. But I've got sixteen dollars. The girl at the window had given me a senior citizen discount. According to that girl I look like I'm sixty five years old.

The height of my bachelor days was back in July of 1974. I picked up Betty from a restaurant, drove to the beach in Far Rockaway and made love to her on the beach. I drove back to the city, picked up Beauty from the Playboy Club and made love to her. The next day, I hooked up with Serena, the belly dancer. We went to a movie and had dinner, and went back to my place and made love. So in a 24 hour period, I made love to these three gorgeous women.

Now, looking back on my life, was that the right thing to do? One of these women would still be with me today if I was a faithful kind of a guy. I had my chances and I blew it.

Sometimes I get a little depressed. And I'm the type of guy that when I bleed, I like to bleed alone. The woman who gets me now, is going to get one helluva deal. I'm a catch. I'm HIV negative, and I've done all those fleeting moment things.

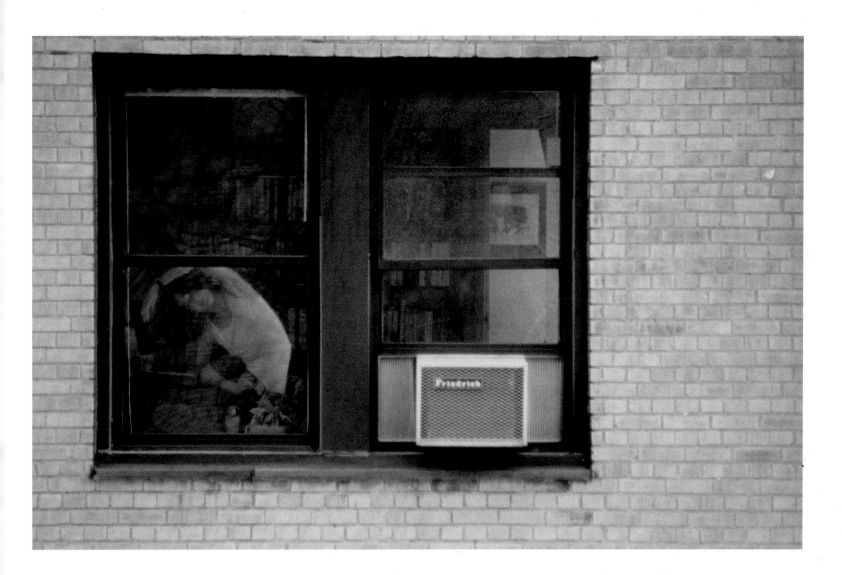

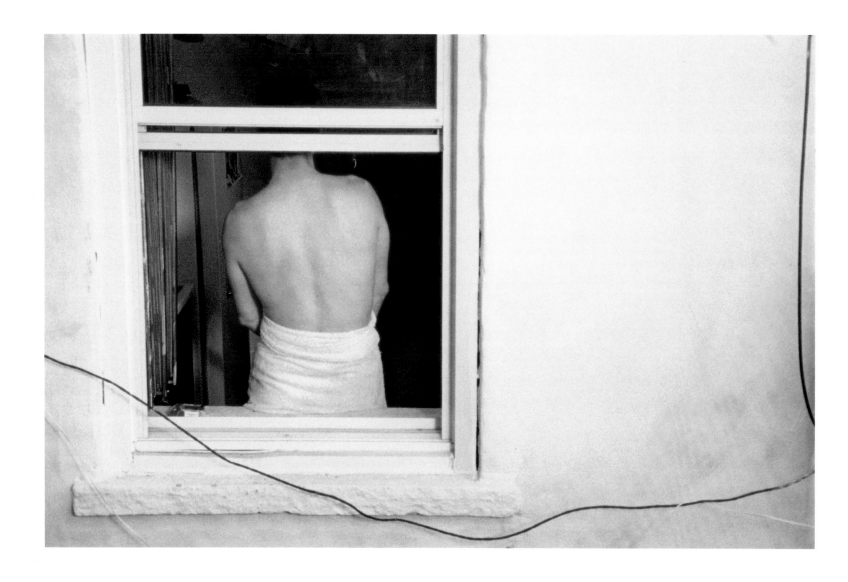

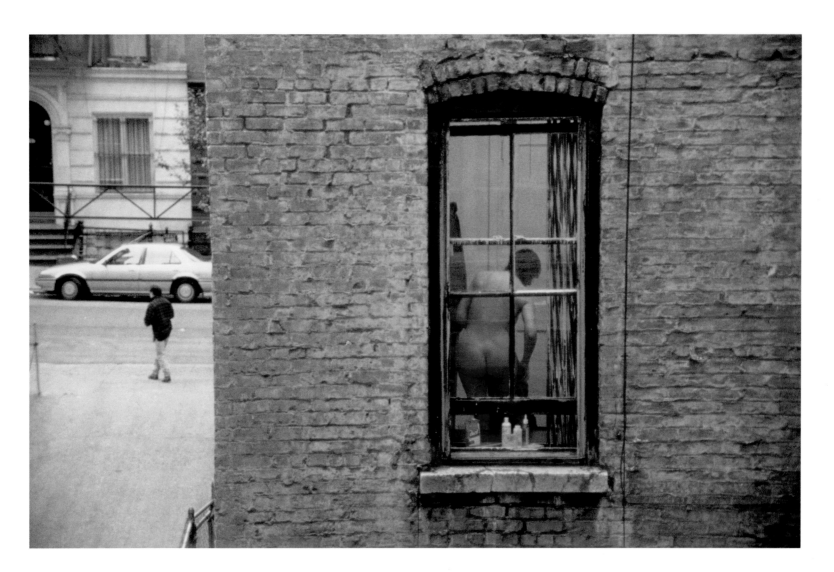

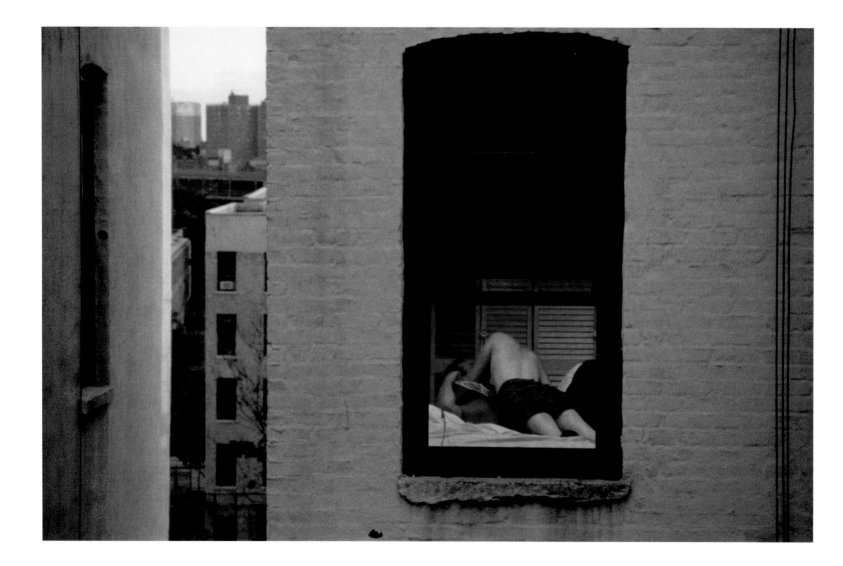

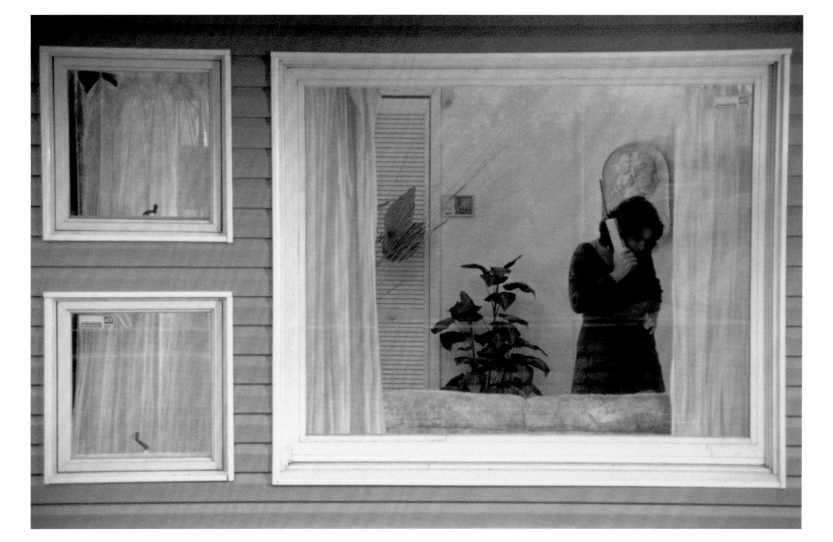

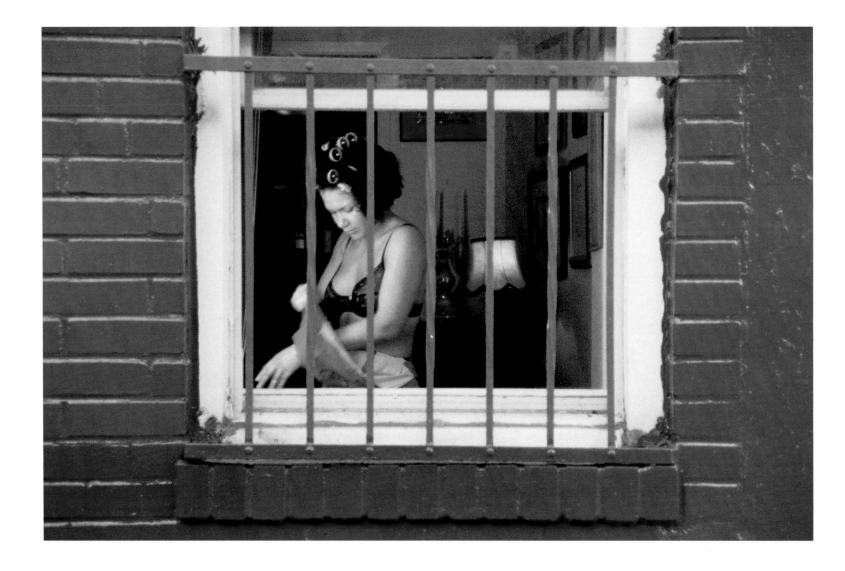

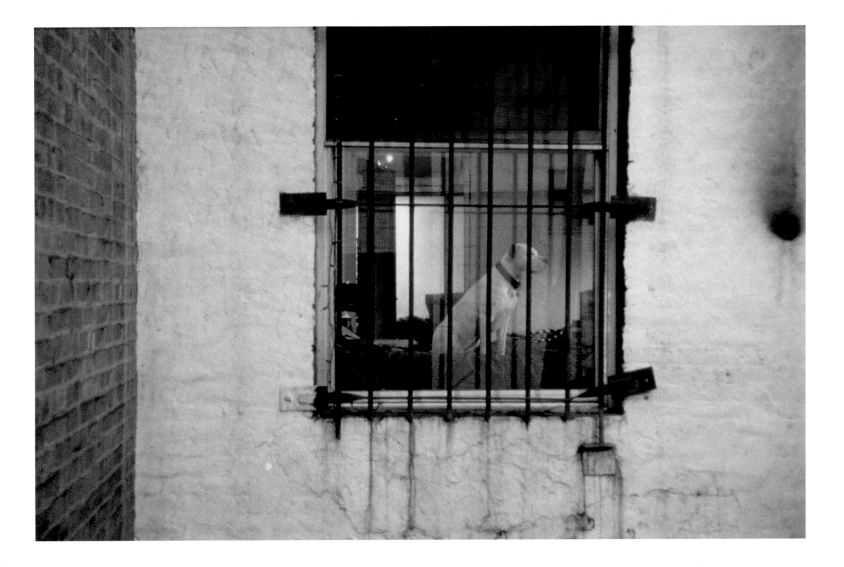

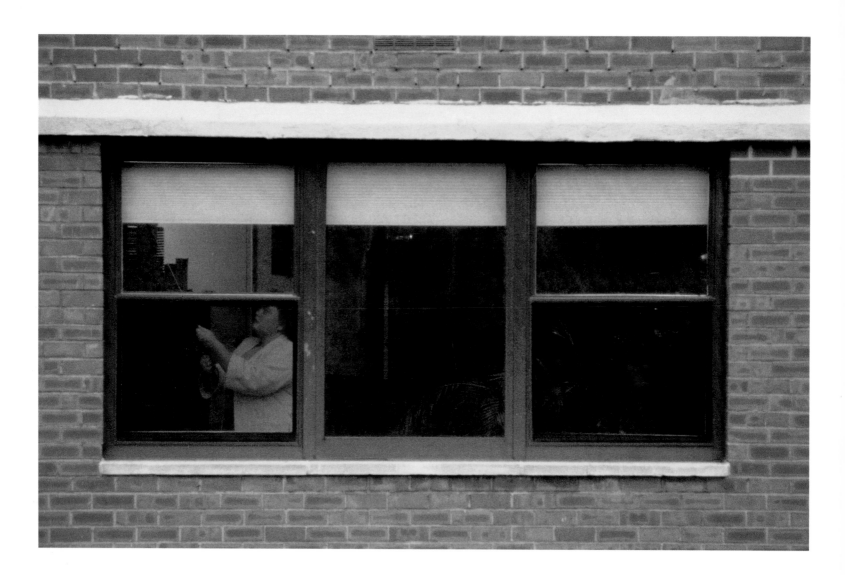

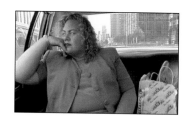  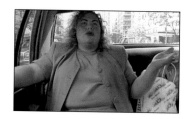

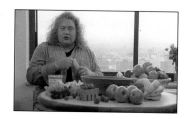  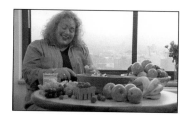

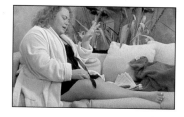 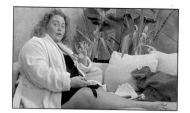

Getting a man is my full time job. I mean that's all I can think about. That's all I can do. And it's very time consuming. I mean I am totally freaking out. I mean 28 and unmarried. It's absurd.

What I'm finding is most of the men in New York do not want to get serious, I mean, at least with me. You know, I feel like saying "Listen, I have a good job, I have medical insurance. You're 40 years old, you're a loser, you have no job, you have no health benefit. I mean, aren't I a benefit to you." I don't know what in hell I'm supposed to lure them with.

I'm really looking for something long-term right now. I don't want to go out to a bar, get drunk, sleep with someone and regret it for the next few months. I don't have that kind of time to waste. I just don't.

The way I flirt is this. And it's so ridiculous. I'm at a bar, I see a guy and scribble a note down on a cocktail napkin and I leave it with the bar tender. I don't even give it to the guy himself. Or I do something as suave as this. I get off my bar stool, go walking to the ladies room and I trip and fall on him. I mean these aren't the greatest techniques I have to say.

I just got back from my summer share at Fire Island and it was a terrible weekend. I started to get very sentimental about my break-up with Nick. I just couldn't figure out why we broke up, so I decided to give him a call and find out why. So I called his number, and wouldn't you know it, a woman answered. I was so mad. I can't even begin to tell you. Here I am at Fire Island, weepy-eyed over this jerk and he's already sleeping with another woman.

I don't know. Something just clicked inside me and I thought "I'm gonna give you a night of fucking terror." And as childish as that sounds that's basically what I did. For two hours straight I called every ten minutes and hung up – just hung up on them. And as silly as that sounds, it really made me feel great.

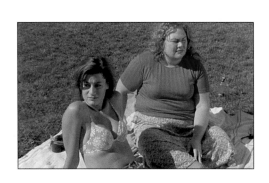 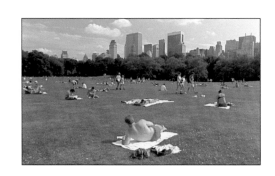

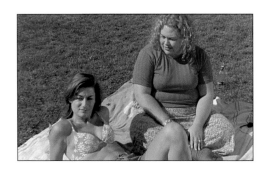 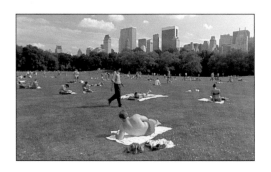

**AIMEE:** Lori, look at that guy. He's kind of cute.
**LORI:** I can't see his face but he has a nice body.

**AIMEE:** My friend Nicki brought in this book she was reading. It's all about how you have to play hard to get.
You know: "Don't ever talk to a guy first." "Don't ever look at a man in a bar." "Don't ever call a man back."
**LORI:** Well, there are women who are prepared to do it, and they're ruining it for the rest of us.

**LORI:** If I was a man would I rather have a good cook or somebody who is great in bed. I would pick the person who is great in bed because you can always order out, go to a restaurant, hire a cook.
**AIMEE:** Would you like to have a good handyman or somebody good in bed?
**LORI:** Somebody good in bed – hands down. I can hire a handyman. But probably men think "I can hire someone who is good in bed." That's the unfortunate truth.
**AIMEE:** Now we're getting bitter!

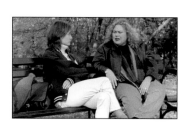
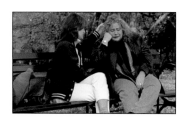
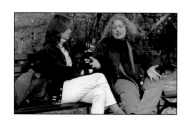

■□□
□□□
**LORI:** Well Amy, I guess it's another summer down the tubes. Our big Fire Island plan didn't work. We're still single. I'm sort of over men right now. This whole summer I feel like I've been through a wringer. Maybe we should take a break from thinking about men for the next couple of months.
**AIMEE:** But I can't. Can you?
**LORI:** No.
**AIMEE:** Good advice!

□□■
□□□
**AIMEE:** Speaking of devastating experiences, I've just got back from seeing Mark in LA. And it wasn't just that he was my first love. It was more the fact that we sort of fell back into a couple's pattern. But it's ridiculous because he's gay now, and he's been gay for like six years. And to top it off, he laid it on me that this girl he went to college with had asked him to be the sperm donor to father her child.
**LORI:** You're kidding me? Is he going to do it!
**AIMEE:** Yes, that's the devastating part! I immediately started bawling. Because Lori, as sick as it is, that was my plan – like in the back of my mind. I mean, he was my first love, he's gay, he wants kids. If I don't hook up with someone he would be the father of my children.
**LORI:** Did he know this?
**AIMEE:** Well, we hadn't talked about it. I just thought it was understood....

□□□
■□□
**AIMEE:** I'm a wreck – just totally a wreck. I find myself obsessing about things like my grandparents having their 50th wedding anniversary and I'm never gonna have that, Lori. We're never gonna have that.
**LORI:** We might not have 50 years, but we'll have 25 years. I mean some people have 50 miserable years. Think about that.

□□□
□■□
**AIMEE:** It's really hard for me in the Fall. It's when I feel the most desperate.
**LORI:** Why do you think that is? It's a new season. Summer's over.
**AIMEE:** It's just so hard when it's something you can't have. I just feel like there is no hope. And it crushes me.
**LORI:** Come on Sugar, it's not that bad.

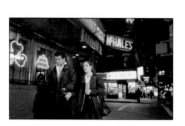 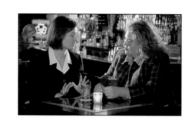 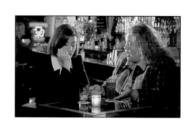

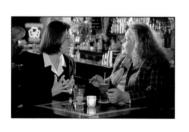 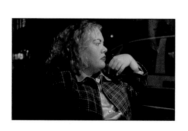 

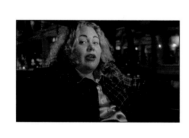 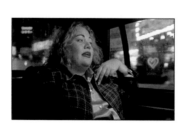 

**LORI:** So Aimee, I've been doing a lot of thinking and this is what I've decided. I'm going to be married by the end of this year, no matter what I have to do. I'm gonna pick one of these three guys that I've had a relationship with over the last few years and I'm going to go with it. I can't fuck around anymore, I'm 28 years old and I've gotta get married before I'm thirty.
**AIMEE:** My God! I don't even have a relationship that I could try to recycle. There is nothing happening for me.

**AIMEE:** The last ad I placed I made it very clear in my ad "serious relationship only". I don't know how you can make that more evident. That's what I want. That's what I said. And this guy calls me, leaves me a message, "I'm married, beat me". I mean what the fuck is that? What is he thinking...?

**LORI:** I think that if you went through a dating service somebody could weed these freaks out. It's like you wouldn't have to put up with this bullshit. You would have some third party dealing with it for you. I mean either that or lose tons of weight... I'm not saying that's what you should do, I'm just saying you need to come up with an action plan.
**AIMEE:** Lori, I really don't think you are seeing this from my point of view. It's obviously not an option just to go and lose tons of weight. That's not the issue. It's not going to do me any good to go to the gym and lose loads of weight and meet someone. Because obviously I have a weight problem and I've had one since I was five. It's with me for the rest of my life. And generally speaking, I'm okay with it. And I have to meet someone who is also okay with it.

My aunt Betty called me at work and she said "Listen Honey, I talked to the rest of the family", and trust me I'm sure she had, and she said, "We're all in agreement. If you want to have a child on your own, we'll be supportive. I mean, we all think it's really about time that you start thinking in terms of that because we don't know how great your 'man option' is right now."

So apparently my entire family has given up on the hope that I'll ever get married. And I'm telling you: it's a new year now and I haven't given up hope on anything. I should be able to meet a great funny guy and have beautiful children and buy a house and live on Fire Island. And I refuse to give up that dream. At this point I know my family has. But as desperate as I am, I have to believe it will happen. I have to.

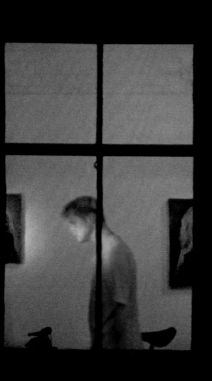

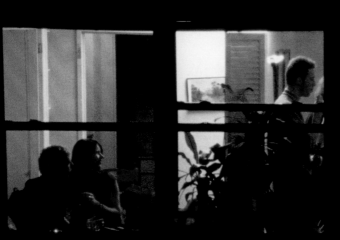

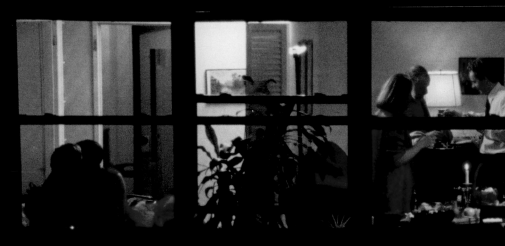

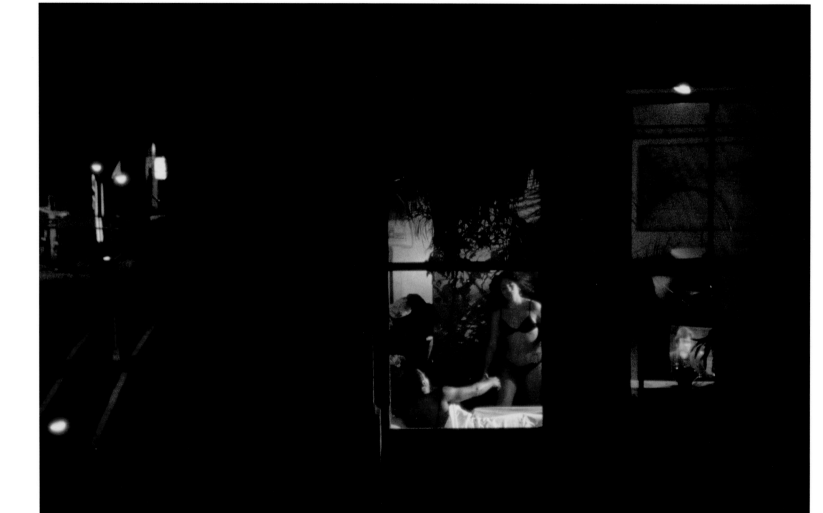

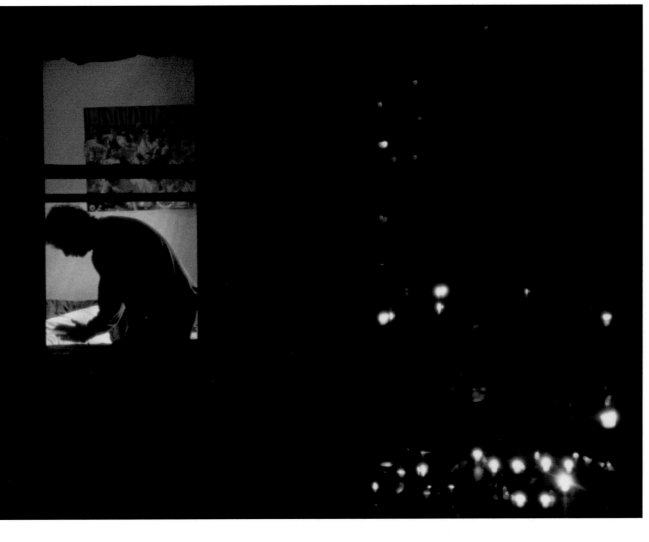

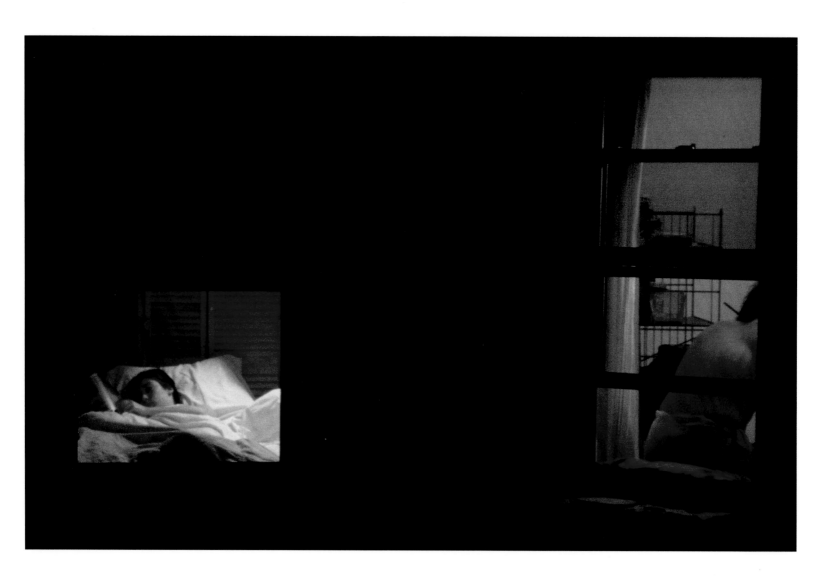

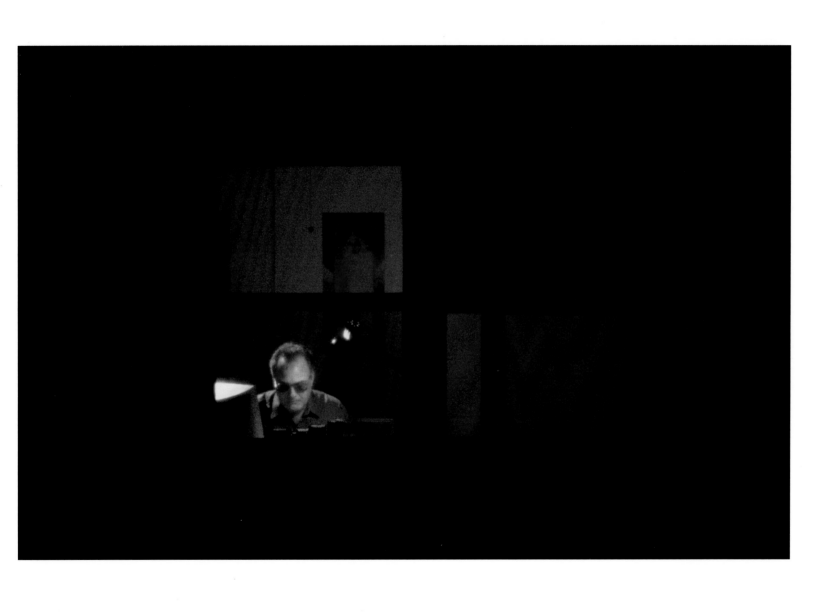

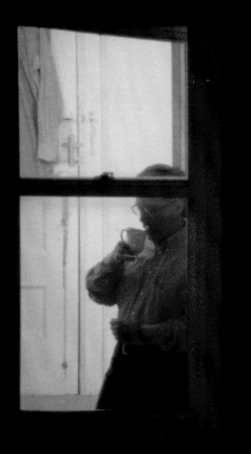

# MICHAEL

 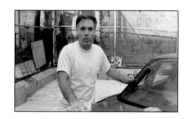 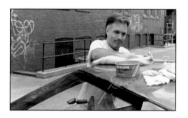

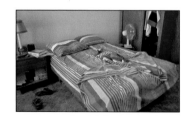 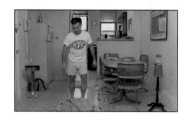 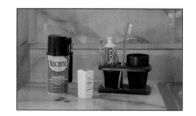

The other day I went on a date and heard the four most terrible, horrible words in the world "Can we be friends?". When a woman tells you that it is basically negating your existence. It's pretty much castrating you. Frankly, I don't want to be your friend. I want what everyone else seems to have out there. I want the whole ball of wax. I want the girlfriend who eventually becomes a wife.

It hit me the other day that I have been doing personals for around 10 years – maybe a little more. And my responses have not been too good. I'd say they've been pitiful. When I answer a personal ad myself, I give what I call the 'truth in advertising' routine. I say, "I'm 5'4, I have brown hair, turning grey at the sides." And I always hear this catch in their voice when they hear "5'4". Because frankly, a lot of women want a taller guy. This is the reality. I have to deal with it. So I always say something like this: "Here is what we do. We get together in a public place for a cup of coffee. If you take one look at me and find you want to projectile vomit, just come over and say "Look, I don't think this is going to work out. Good night". And I'll say: "No problem, good night." And we both go home intact.

Women always say they want to go out with nice guys. But they don't go out with nice guys. They go out with creeps, jerks and scum buckets – guys with cool lines like "Hey baby, your eyes sparkle". And women fall for it. And they give it away to these clowns. These women confuse arrogance and ego with self-confidence. I don't know why some women – not all – can be so incredibly stupid. If I was one of the bullshitters I would be getting it regularly myself.

I'm the only child of an Italian-American family. So basically all the bets are on me. And for a long time I used to get calls from my mother saying "Guess, who got married? Guess who is having a baby? Guess who is having another baby?" Finally it got so annoying, it got to a point where I said "I've had enough. I don't want to hear these stories anymore. All I want to hear is bad news. All I want to hear is stories about people being hit by buses." But they kept the pressure up. They kept banging at me, "What's wrong with you? What's wrong with you?" And I finally said, "I've had enough. Listen, no more of this. I have to tell you flat out, I'm not a homosexual...Okay!"

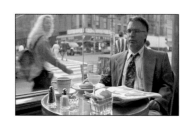

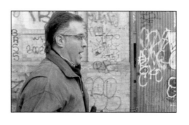
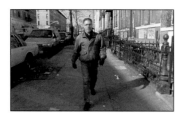

This woman just called me and referred me to her ad. So I checked it out, and there was this little proviso in there. She was looking for a guy who was 5'10 plus. I said to myself, "Here we go again: the baby boomer rulebook rearing its ugly head – the man must be taller than the woman."

Well, surprise, surprise! That woman who said she doesn't date men under 5'10 actually called me back. So, we're talking, and I mention that opinion I've had for a while about women who hang out with effeminate homosexual men. And suddenly she clamped up and said, "I don't want to talk anymore. Good Bye." I was a little disappointed. But when I thought about it, I had to laugh. She must be one of those women who spend so much time hanging out with Timmy, the choreographer and Donny, the make-up artist. And that's why she's still single. Why do these women hang out with effeminate homosexual men? How do you expect to meet guys if you're wasting your time like this? I mean, really, grow up!

Against my better judgement I've decided to see that woman they call a 'dating coach'. Frankly, I think this is really a last gasp. I mean a 'dating coach'! If you are learning a new skill, like skiing or golf or tennis, you need someone to help you with the technical details. But having a life, you are supposed to do this on your own.

DATING COACH: Do you think you have the right attitude or do you think this negativity is shining through. And even though you are going out there as much as you do, you're giving off these negative vibes that are not making you seem very attractive to people.
MICHAEL: I honestly don't know. I've tried theatre groups. I've tried my skating group. I've gone to wine tastings. I've done art gallery openings. I've tried fencing...
DATING COACH: What about dog walking? Do you have a dog? Do you enjoy pets at all? Because dogs are people magnets, you know. And the park in general is a great thing to do.
MICHAEL: I've done that, and some dog comes by and you say "Hey, how are you?" And you scratch him and pet him. But I'm not a smooth operator. I can't just pet some attractive woman's dog and scratch him and have a good time. Because she is out walking her dog. She wants to get home.

I remember last winter, stuck in the house – all the snow, the cold and the grey. And you've read every book in the house 19 times and you wonder "What the hell do I do now?"

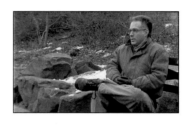
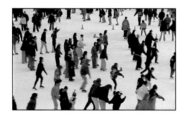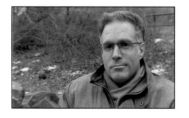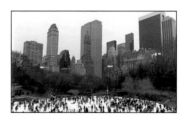

A few years ago a gentleman who lived downstairs died. Now, he had a brother and sister come over to clear out his apartment. And you saw in the garbage all the detritus that a human being collects over a lifetime – books and papers and things and stuff. And it suddenly hit me that if I remain a bachelor – a word I despise – all that will be left of me is stuff. And since I am an only child, strangers will be going through my stuff. Now I'm 40 years old. Men are not supposed to think in these terms. But frankly, I'm afraid of dying alone.

Over the holidays, I made my annual Christmas pilgrimage to my folks down in Florida. And although nothing was said, I felt it, or at least I heard it in my head, "You're still not married. We still don't have grandchildren". So I decided to limit my visits to Christmas and not come back until I have a wife.

While I was away, I had the time to think about things. Some friends have told me "Don't try so hard". And frankly they're right. I don't want to appear desperate. And I do have a tendency to come off as a little intense. So I'm gonna work on that. Otherwise I've hit the New Year running. I've signed up for a course called "Cooking for Singles" – hopefully it won't be a geek-fest. I've purchased a book called 'Entertainment '97' which features discounts and offers for museums, other events and special deals for solo diners. So I'm gonna take advantage of that. For my final resolution, I have given up on the personals. It just doesn't work for me. You put an ad in. You call somebody on the phone, you meet and nothing happens. So it's not like someone could say, I haven't tried. Because I have. So you just move on to other things.

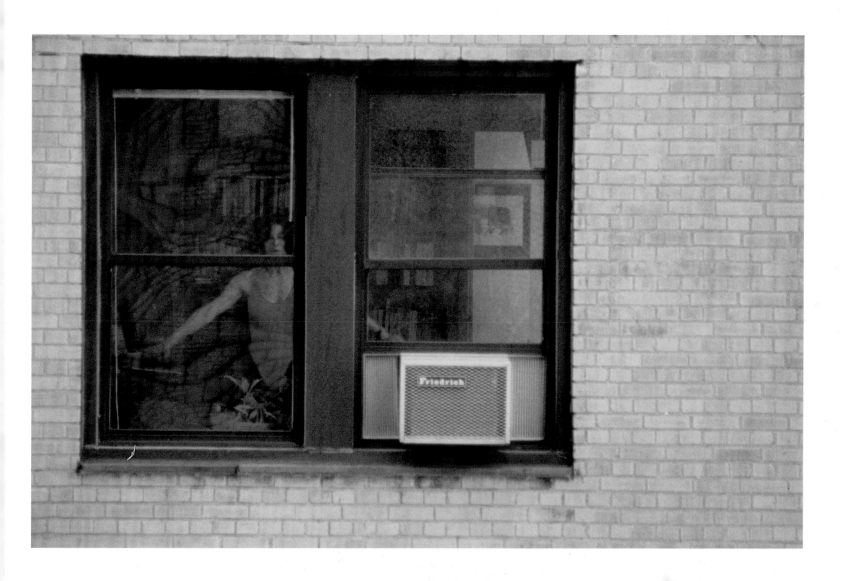

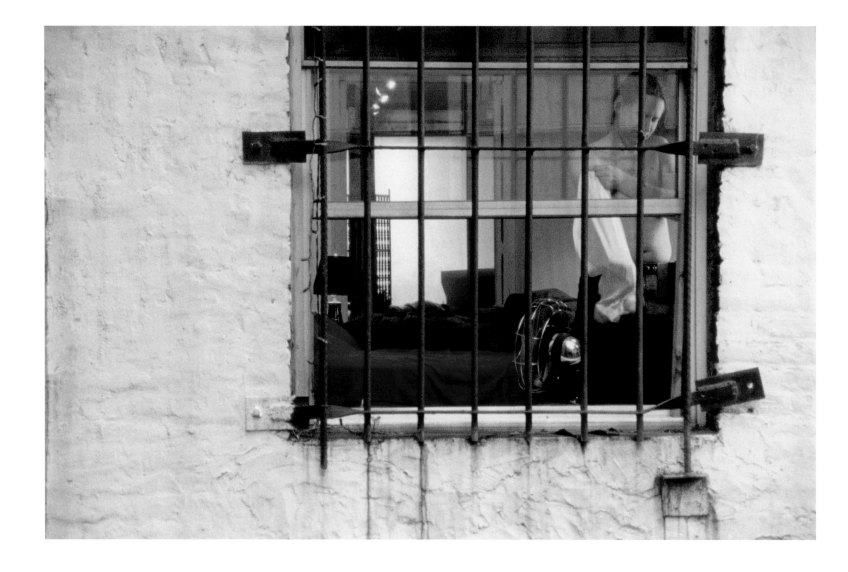

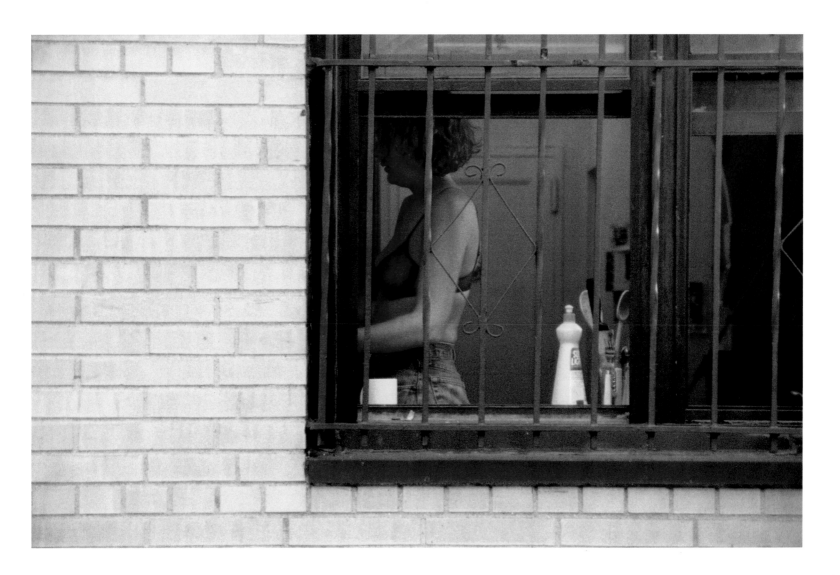

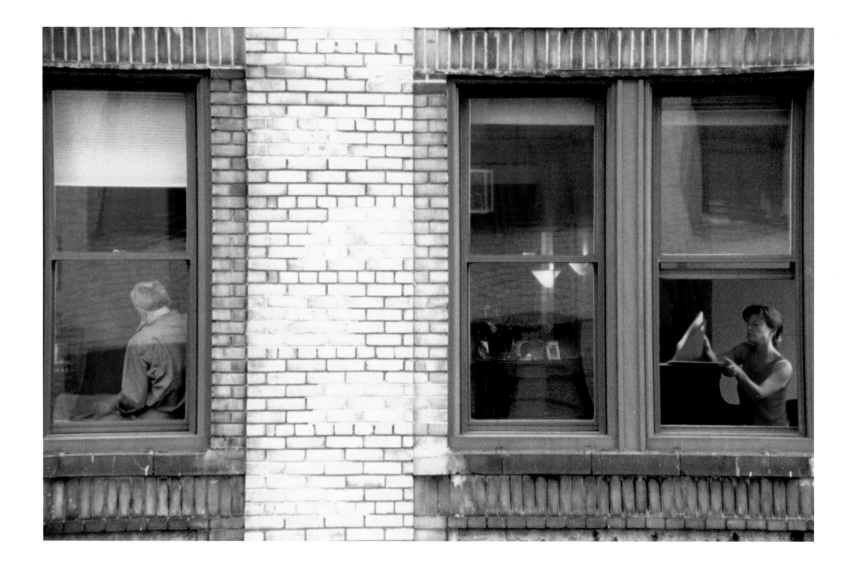

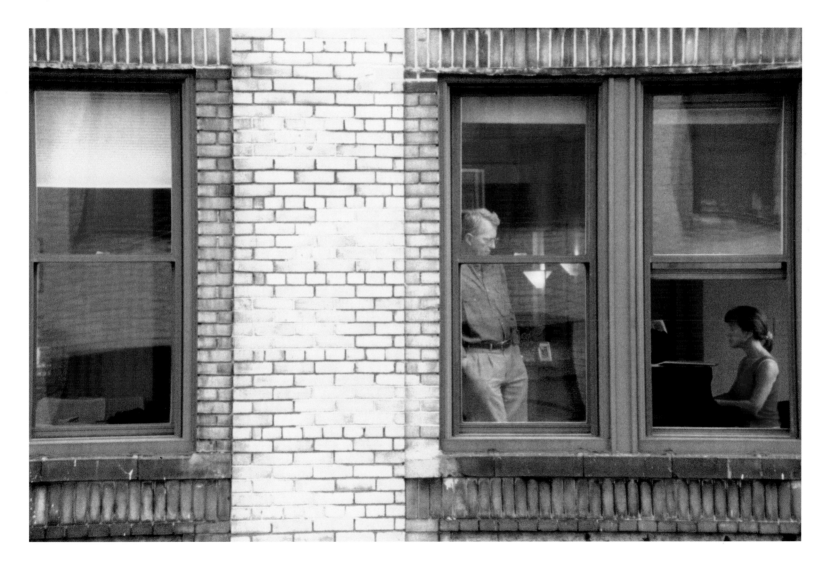

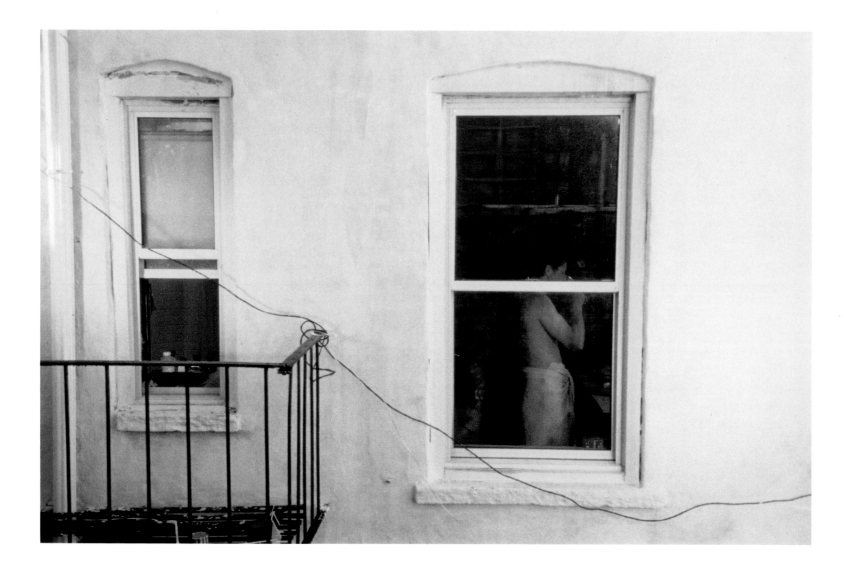

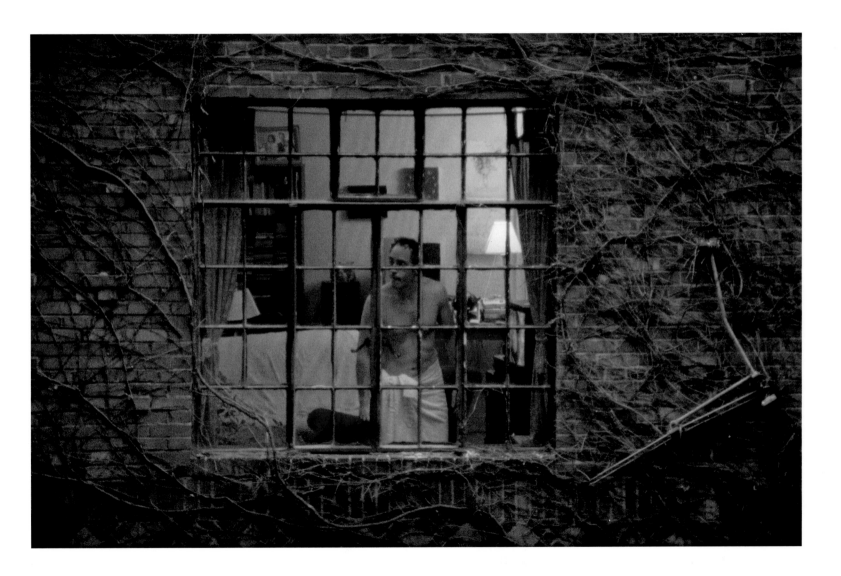

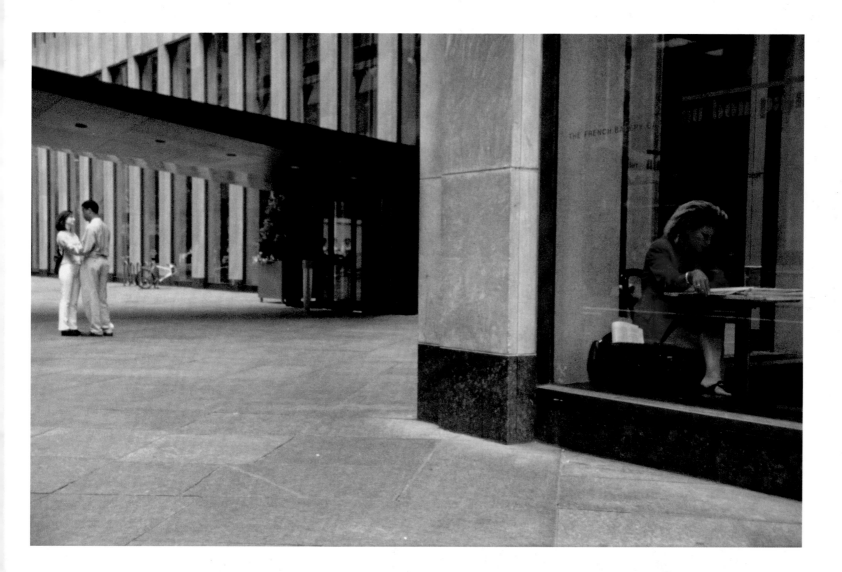

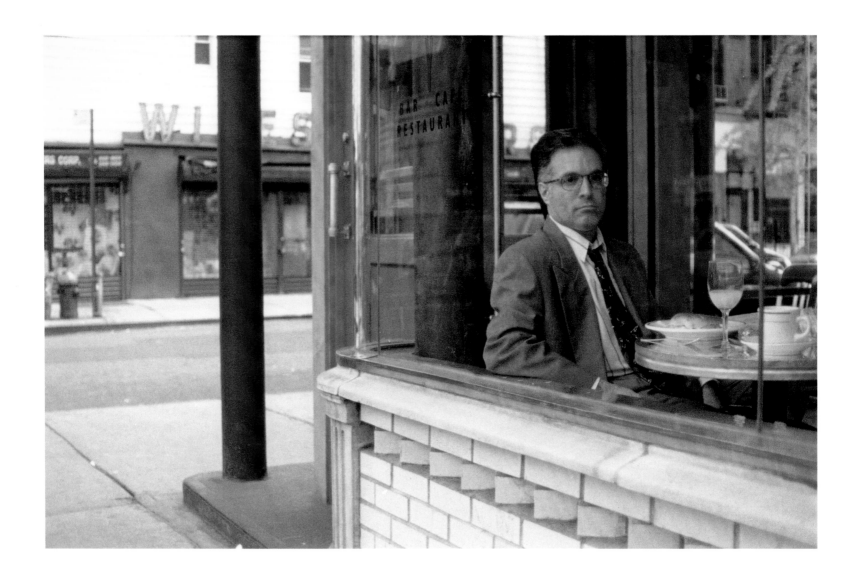

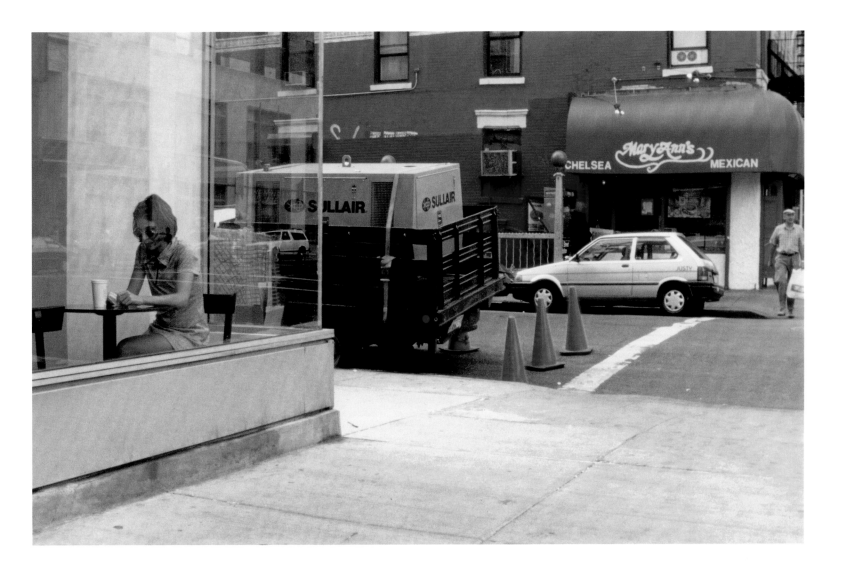

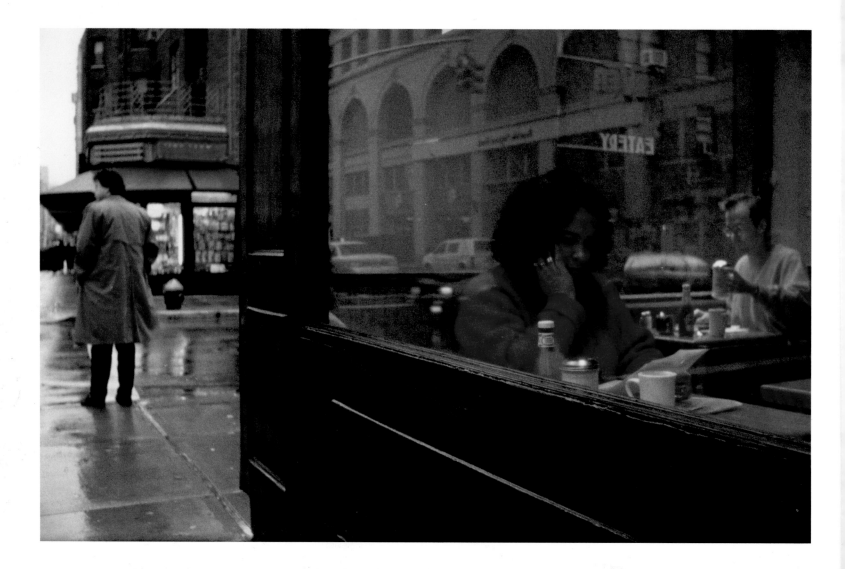

**Special thanks to the following:**

Lighting Cameraman: William Rexer
Assistant Cameraman: Ian McCausland
Gaffers: Shawn Sullivan, Alex Klymko
Negative Cutter: Byron Erwin

Production team (New York): Sam Bickley, John Delk, Ann Rose, Katya Rogers,
Karen Baker, Birgit Staudt, Gretchen McGowan, Ulla Zwicker, Marcello Bue, Steve Wax

Production support (London): James Garrett and Partners, Tom Jacomb of Soho 601,
Ray Stevens, Michael Robey

The principal cast: Aimee Copp, Lori Worcester, Brenda Monte, Gina Direnzi, Toto,
Michael DeStefano, Mikey Russo, Ivan Martin

Additional characters: Clyde Baldo, Tracy Bickley, Miriam Biddleman, Pia Carlson,
Martin Cribbs, Eric Delaforce, Elizabeth Durharn, Rose Edwards, Paul Fulton, Elizabeth Jarr,
Lisa Lauer, Cynthia Lilley, Peter Lilley, Brian Madigan, John Rexer, Doug Rogers, Donna Roses,
Julie Saul, Lee Shoulders, John Van Clief, Thomas Wilson, Susan Witty, Jesse Zwaska

And the many other people in London and New York who generously assisted this project

First published in the United Kingdom in 1998 by

Dewi Lewis Publishing
8 Broomfield Road
Heaton Moor
Stockport SK4 4ND
England
+44 (0)161 442 9450

ISBN: 1-899235-26-4

Artwork Production by Dewi Lewis Publishing
Based on an original design by Peter Chadwick @ ZIP Design
Photo Prints by Charlie Meecham, Outsiders Photography
Small Image Scans by Rich Montez
Reprograhics by Leeds Photo Litho
Printed in Hong Kong by Everbest Printing Company